T0397874

OF A FEATHER

of a feather

Photographs by Thaddeus Holownia

Poems by Harry Thurston

THE ANCHORAGE PRESS 2024

"Hope" is the thing with feathers
EMILY DICKINSON

In memory of Gay Hansen

BLUE JAY
Cyanocitta cristata

Unseen in summer, woods-deep,
come fall, you return,
casting voices, your own
and others you mimic.

Not blue at all,
your feathers
bequeath only blue
light to the eye.

Clever corvid,
you may change a life!
—with a beat of your wing,
a call we must heed.

NORTHERN HARRIER
Circus hudsonius

In this place of wind,
of grasses in concert,
corrugations of rushes,
whistlings through
the ghosts of barns,
darkness of covered bridges—suddenly,
low over
the sedges, golden rod, and timothy,
stalled in the middle of the world,
as far as the eye can compass,
you hover,
stopping time, silently lethal,
as the sun crimsons your back,
the tin sound of an overflying Cessna
ruins your air—Harrier,
the more perfect animal
in its element.

AMERICAN KESTREL

Falco sparverius

Little falcon
you hang

upswept
in wind

open heart
ablaze

nimbus back
spied

only by
higher hawks

as you
descend

a dark cloud
earthward

RED-TAILED HAWK
Buteo jamaicensis

You came with the snows,
tail aglow, an ember
in the cold hearth of winter.

I knew when you might appear,
looked through winter's scrim
to the ragged treetops

where you perched in my scope,
breast feathers ruffled, their heart shapes
a shield against the pointed winds.

On those meagre days, we shared
twin desires, for warmth and living
motion to feed our eye-hunger.

NORTHERN GOSHAWK
Accipiter gentilis

Looking for goshawks is like looking for grace.
HELEN MACDONALD, 'H IS FOR HAWK'

Goshawks are hard, she says.
You come clattering through the trees,
talons ready to rake the scalp
of those too close to your nest.

How is it then, you return
to a gloved hand, don a hood,
so that you and she might grapple
grief together? Is that not grace!

SHARP-SHINNED HAWK
Accipiter striatus

Littlest hawk, you are always there as I play through holes 10
and 11, or coming home on 17 and 18, flighting my egg-like
ball down the fairway, invading your skies, or spraying it into
your woods.

Your woods: you have been there how many years? But then,
who's keeping score! Of course, it is not the same 'you'; it has
been too long for that, lifespans being what they are, yours
and mine.

If I did not hear that irritable screed—Keek! Keek! Keek!—as
you swoop through the trees, putting a tail-feathers' rush to a
crow or other interloper, like me, or knocking songbirds into
silence, the stuffing out of them like a *featherie goff* ball, there
would be a hollowness, the knowledge the game is up, the
numbers all in.

GREAT HORNED OWL
Bubo virginianus

Owl is presence,
bulk in the branches
presiding in your parliament of trees,
in silhouette, apart, self-possessed
in your solitary pose.
All ears, swallowing the space,
the silence all around.
You wait out the daylight hours,
await the night—for flight,
to imprint your feathers
in the snow, parcel
a perfect bundle of bones.

SNOWY OWL
Bubo scandiacus

Lean years, the Arctic comes near,
irrupts south to this treeless plain

as if it were at home
in the unbroken whiteness.

Essence of essences, Thompson says,
but under that stark purity

lurks the terrible talons,
hardly an afterthought

but the lethal point—
intimations of eternal life.

—

BARRED OWL
Strix varia

A cascading
of line and light,

a cross hatching
on your breast

like etching
on a copper plate

or the bars
of a musical score.

How many beats
do we hear?

Hush, listen—
let us count

the notes
of your night song,

its constant
questioning,

in answer
attend the silence.

RING-NECKED PHEASANT
Phasianus colchicus

after Buson

Pheasant's mournful cry
calling back the poet's soul
across the river.

HELMETED GUINEAFOWL
Numida meleagris

Your heart is a firmament,
lights all the way out—

to the end of time,
to the beginning.

Stars being born, burning out,
galaxies aswirl,

the tracks of meteorites
incoming on August nights,

tracing the darkness
that lies behind all things.

EUROPEAN STARLING
Sturnus vulgaris

A racheting in the ear,
a spiralling in the air,
starlings mob Rome's twilight,

while in the New World
Shakespeare's bird hijacks
woodpeckers' homes.

SPRUCE GROUSE

Falcipennis canadensis

You are a scent,
something apprehended
before you are seen—
a mouldering of leaves
kicked up. Or a distant
report, a handclap,
brushes whooshing a snare drum.
Then, strutting into the open
you deploy a carnival
of feathers, fanning out—
a burlesque, all under
the quizzical arches
of your flaming combs.

NORTHERN FLICKER
Colaptes auratus

'Common' they used to call you
and I do see you often
in the backyard, head down,
diligently drilling, beak in the dirt
siphoning up beetles and ants,
your daily fare—

commonplace, even pedestrian.
Yet when you are sated
and take to wing,
you become a blaze of light,
a yellow-shafted phoenix
rekindling the day's ashes and dross.

COMMON NIGHTHAWK
Chordeiles minor

It has been years,
you are rare. Now
you appear in this hour
when stillness falls
on the land, the water
is calm as a clock.
You scribe
the architecture
of the sky
with the uncanny calculus
of your scimitar wings,
their white epaulettes
like chalk lines
struck in air.
Seeing you again
after long absence
I ask, how did
the scaffolding
of dusk hold up
without you?

GREATER YELLOWLEGS
Tringa melanoleuca

Like the first hoarfrost of fall, the coming of winter, your breast
is a flowering of feathered ice. Your sudden appearance, drifted
down on Arctic air, raises alarm. The season turns, there is no
looking back.

"Dear! Dear! Dear!" Your discourse is insistent, unrelenting
as Time's Arrow, though, look—you bank sharply in flight!

Your image doubled on still water.

Circus bird, balancing on those yellow stilts, you come from
the skies in a golden season, a winged Calliope in full voice,
to shake the tilted Earth.

Seeing you now, hearing you again after a summer's absence,
my heart opens, warmly at first, yet with an inevitable chill.

WILLET
Tringa semipalmata

Brave bird, flashing your chevrons
over the deep green of your marsh Eden,

you wake the world reborn
out of the ocean each day.

Whenever I hear your joyful talk,
I am called back to our Earth-home

where water and land are moon-mingled,
I am returned to our common Garden.

COMMON EIDER
Somateria mollissima

I. MALE

At sea
eiders ink the horizon,
a binary of black and white,
integers stippling the metallic-sheened waves,
slopping among the mussel-shoals and reefs—
the skerries uplifted 'down on the Labrador'.

In a Zodiac,
Pompey Island, 530 47' N
to Black Tickle, 530 27' N,

119 islands in all,
large and small,
37 with nesting eiders.

II. FEMALE

On land
walk the perimeter abreast,
then grid the interior,
to find the "brown eiders"
and their nests—
2242 gyres of heat,
comfort against the cold currents
along that stormbound coast.

WOOD DUCK
Aix sponsa

We name things,
need words to connect
to the myriad others

not ourselves. Even so,
sometimes we have pinned
our own name as a kind of claim

to another's separate being
(so-and-so's Shearwater or Oriole).
Better to name a thing

for how it looks, where it lives.
That is the way for you, Wood Duck,
who perches and nests in trees.

Even your naming in Latin
as *the bride adorned in
wedding raiment* seems to fit.

Yet no name can possess
your individual beauty,
your right not to be named.

COMMON RAVEN
Corvus corax

I wish I could see
into the black box
of your mind.

I look into your nest
tipped from a marsh barn's
eaves—

you were a weaver,
your beak shuttling sticks
into concentric circles,

whirling to a soft centre
of grasses and the blond hairs
of a mare's tail,

bound
at the perimeter
by baler twine.

I wish I could see
into the black box
of your mind—

even the glass eye,
the curious cock of the head
in this mounted specimen

is wise.

HEART OF THE BIRD

This is the last of three book projects on birds, a trilogy, in which I have collaborated with Thaddeus Holownia. But there is a third person who has contributed to these projects in an integral way and should be considered a collaborator, or perhaps more accurately, a muse—Gay Hansen, teacher, naturalist and ornithologist, and the late partner of Thaddeus.

Gay was a lecturer and lab instructor in biology at Mount Allison University, in Sackville, New Brunswick, for 39 years (1979–2018). During this time, she conducted labs in multiple fields, including Animal Biology, Parasitology, Chordate Anatomy, Coastal Marine Biology and Ichthyology. Her great passion, however, was Ornithology.

"I think that it is essential to educate people about birds— they are extremely important in ecological, environmental, cultural and recreational realms," she once wrote. "Ornithology is one of the few fields of Biology where citizen science makes significant contributions."

Gay was also a talented craftsperson, notably as a weaver, and she combined her love of birds and her manual skills in taxidermy to create a collection of study mounts. These mounts inspired the photographs and poems collected in *of a feather*.

One of these mounts 'changed a life' as I intimate in the poem "Blue Jay, *Cyanocitta cristata*." In fact, it changed two lives as it was this bird that brought Gay and Thaddeus

together. Thaddeus tells this story in *Lightfield, The photography of Thaddeus Holownia*, written by his friend Peter Sanger:

[Thaddeus] discovered a dead blue jay lying on the road ... He was deeply moved by the bird's beauty and saddened by its death. Rather than throw it in the ditch to rot or be picked apart by scavengers he impulsively took it with him back to Sackville. Friends suggested he take it to the Biology department to see if it could be preserved as a specimen. That is how he first met Hansen.[1]

Another of these mounts was the inspiration for "Common Raven, *Corvus corax*." The vital look of this specimen as well as a perfectly preserved raven's nest, also collected by Gay and Thaddeus from a fallen Tantramar marsh barn, made this poem possible when I first encountered them at the Gay Hansen Ornithology Lab.

Gay also was responsible for acquiring an historical collection of bird eggs as study aids for the Mount Allison Biology Department. These eggs were the subject of the first book of the bird trilogy, *Ova Aves*. And she played a critical role in the second book, *Icarus, Falling of Birds*, when as an expert birder she was called upon to help identify some of the 10,000 migratory wood warblers incinerated by the illegal flaring of gas at the Canaport Liquefied Natural Gas plant in Saint John, New Brunswick, on the night of September 13th, 2013.

Gay and I both graduated in Biology from Acadia University. Gay went on to complete her master's degree, studying the habits of the Willet, *Tringa semipalmata*. (It happens to be my favourite bird, having grown up with its clarion calls along the saltmarshes bordering the Chebogue River, in Yarmouth

1 Peter Sanger, *Lightfield, The Photography of Thaddeus Holownia.* (Kentville, NS: Gaspereau Press, 2018).

County, Nova Scotia, that served as a Canadian refuge for this species during the first half of the 20th century.) I had already begun to write poetry while an undergraduate at Acadia and instead of continuing my studies toward a working career as a biologist, as Gay did, I became a writer.

It seems that our careers veered radically at this point—one toward the Sciences and the other to the Arts. This assumption is a common fallacy in our time—that there is an unbridgeable gap between these two spheres of human endeavour. This notion of incompatibility between the sciences and arts was promulgated by the novelist and physicist C.P. Snow in his famous essay, "The Two Cultures,"[2] first published in 1959, and it only seems to have gained traction since then. This is an idea that I neither embrace nor accept. I am not alone in my opinion. The American poet and essayist Alison Hawthorne Deming argues that she could not see what Snow saw, "the intellectual life of the whole of western society split into two polar groups." On the contrary, she says, "I have always been struck, perhaps naively, by the fundamental similarity between the poet and the scientist: both are seeking a language of the unknown."[3]

She thinks of "poetry as a means to study nature, as is science," and that "the poem's enactment is itself a study of wildness, since art is the materialization of the inner life, the truly wild territory evolution gave us to explore."

Rachel Carson, the mother figure of the modern environmental movement and herself both a poet and scientist, said that there could be "no separate literature of science," since science and literature had the same aim, "to discover and illuminate the truth."[4]

[2] https://www.rbkc.gov.uk/pdf/Rede-lecture-2-cultures.pdf.

[3] Alison Hawthorne Deming, in her Bayer Award in Science Writing essay "Poetry and Science: A View from the Divide." Published in *The Edges of the Civilized World: A Journey in Nature and Culture* (New York: Picador, 1998).

[4] Rachel Carson's acceptance speech of the National Book Award for Nonfiction (1952).

I will bring only one more specimen to this argument in favour of the compatibility, and in fact interdependence, of the arts and sciences. Edward O. Wilson, Harvard biologist and one of the 20th century's most important scientists, observes that "neither science nor the arts can be complete without combining their separate strengths. Science needs the intuition and metaphorical power of the arts, and the arts need the fresh blood of the sciences."[5] What Wilson is saying is that science and the arts can be, and should be, collaborators.

The photographs and poems in *of a feather* would not have been created without Gay's skills as an ornithologist and taxidermist deployed originally for the purpose of passing on her knowledge and love of birds to her students, and to generations of students to follow.

The feather is "a remarkably refined and complex apparatus … that, among other uses, enabled highly sophisticated flight."[6] But besides feathers' functionality they are truly beautiful. That is what one feels when first looking at these photographs of feathers—*How beautiful they are!*

It is no accident, I think, that Holownia's photographs are of breast feathers—of the heart of the bird. H.T.

5 Edward O. Wilson, *Consilience: the unity of knowledge* (New York: Alfred A. Knopf, 1998).

6 S. David Scott and Casey McFarland, *Bird Feathers: a guide to North American species* (Mechanicsburg. PA: Stackpole Books, 2010).

Acknowledgements

I want to thank again my friend Thaddeus Holownia for his invitation to collaborate on this project, a trilogy, focused on birds, including *Ova Aves* and *Icarus, Falling of Birds*. I am grateful to Arts Nova Scotia for funding, under the Grants to Individuals Program, which provided support while I worked on these poems. The poems and the photographs had their source in the lifelong work of Gay Hansen whose taxidermy teaching specimens are housed in the Gay Hansen Ornithology Laboratory at Mount Allison University.

Italicized passages in "Sharp-Shinned Hawk, *Accipiter striatus*" refer to Thomas Mathison's poem "The Goff," published in 1743. The haiku "Ring-Necked Pheasant, *Phasianus colchicus*" is based on the poem "Mourning for Hokuju Rosen" by Yosa Buson (1716–83). Italicized passages in "Snowy Owl, *Bubo scandiacus*" are taken from John Thompson's *Stilt Jack*, "Ghazal I," and Robert Duncan's poem, "An Owl is an Only Bird of Poetry." European Starlings were first released in Central Park in New York City in 1890, reputedly as an effort to introduce all of Shakespeare's birds into North America. The eco-poem "Common Eider, *Somateria mollissima*" is based on a reading of the scientific study "Nesting Eider Surveys of the Coastal Islands of Southern Groswater Bay, Labrador, 13 June–21 July, 1981" by Gay Hansen. H.T.

For over fifty years, THADDEUS HOLOWNIA has approached his art form with a gentle but persistent nudge to be mindful of our imprint on the land. He is known for his long-term projects, transformed over periods, cycles, and seasons, in which he researches the natural processes of life and the inevitability of change. A keen observer of the environment, his work expresses a deep concern for nature. His reflections are poetic and subtle, meant to call our attention to how we are transformed by ideas, compromises, and ethics. He returns to a subject over years, even decades, and creates a photographic register of the transformation. He resides in rural New Brunswick where he and his life partner Gay Hansen homesteaded in 1982.

HARRY THURSTON is the author of thirty books of poetry, natural history, and memoir. He is the recipient of the Lane Anderson Award for science writing in Canada and the Sigurd F. Olson Nature Writing Award in the United States. Thurston lives in Tidnish Bridge, Nova Scotia, and is a Mentor in the Master of Fine Arts in Creative Non-fiction program at University of King's College.

The photographs reproduced in this book were made by
Thaddeus Holownia using a Fujifilm GFX 100s camera.
The book was designed by Andrew Steeves and typeset in
a digital revival of Monotype Dante. It was printed and
bound by Friesens Corporation in Altona, Manitoba.

ISBN 978-1-895488-62-3

Every year, two awards are given to Mount Allison University
biology students in Gay Hansen's name, one in general biology
and one in ornithology. For information on contributing to these
awards, please email *donate@mta.ca* or call 1-866-890-6318.

THE ANCHORAGE PRESS

440 Jolicure Road, Jolicure, New Brunswick E4L 2S4

www.anchoragepress.ca *www.holownia.com*